This book is published by

The Temple Hoyne Buell Center
for the Study of American Architecture
1172 Amsterdam Avenue
Columbia University
New York, New York 10027

© 2007 The Trustees of Columbia University
in the City of New York
Text © 2007 Brian O'Doherty

Distributed by Princeton Architectural Press
37 East Seventh Street
New York, New York 10003

Third Printing, 2009

Printed and bound in China

ISBN 978-1-883584-44-3
Library of Congress Control Number:
2006940556

Series editor: Joan Ockman
Executive editor: Salomon Frausto
Editorial assistant: Sharif Khalje
Design: Dexter Sinister, New York

Studio and Cube is the first volume in a
series of books related to the FORuM Project,
dedicated to exploring the relationship of
architectural form to politics and urban life.
FORuM is a program of the Temple Hoyne
Buell Center for The Study of American
Architecture at Columbia University.

Contents

Samaras's studio-bedroom —The artist's myth —
Acconci's Seedbed — Courbet's studio — Delacroix's
dilemma — Nesbitt's studio tour — Cultists' club/Warhol
— Utopia now/Rauschenberg's studio/ The Bed —
The tenses of studio time — Studio of accumulation/
Bacon's studio — Studio of reduction/Rothko —
The empty studio/Duchamp — Caspar David Friedrich's
studio —The window —An etiquette of looking/Hopper —
The model —The painting-in-the-painting — Mondrian's
studio — Brancusi's proto-museum —The studio defined
— Perception —The anti–white-cube

In 1964, Lucas Samaras transferred the contents of his
studio-bedroom from his New Jersey address to the
Green Gallery on East 57th Street in New York City. He
reconstituted the studio-bedroom and exhibited it as art,
thereby inserting the space where art is made into the
space where art is displayed and sold. The studio was
now an artwork in the gallery. It was not sold. "...I guess
I wanted," Samaras said, "to do the most personal thing
that any artist could do, which is, do a room that would
have all the things that the artist lives with, you know,
clothes, underwear, artworks in progress. I had books
that I had read, or that I was reading. I had my writing, or
my autobiographical notes. It was as complete a picture
of me without my physical presence as there could
possibly be."

Samaras's gesture superimposed the two spaces —
studio and gallery — where art solicits its meaning. In
his artwork, the mythologies of the studio, which precede
and then parallel that of the white cube, overlapped those
of the gallery space. By placing the studio in the gallery,
he forced the two to coincide, thereby subverting their
traditional dialogue. Samaras exhibited a lifestyle —
frugal, messy, indifferent to the gallery-person's etiquette
of taste. He had, you might say, created a kind of period
room — mid-1960s — in a gallery. Period rooms in

4

museums suggest how a representative of an era lived. By putting on display a lifestyle embalmed in the gallery's artificial time, Samaras was imagining an absent artist: himself. By declaring the residues of the artist's life as art, he reified the image of the absent artist as eloquently as the mourning dog by the empty chair in a Victorian painting calls up the departed master. So, in this work, the gallery framed the studio, which in turn framed the way the artist lived, which in turn framed the artist's implements, which in turn framed the artist — who was missing.

In making his studio-bedroom a conscious work of art, Samaras made, I think, a dandy's gesture. He offered his private life to the public as art. Could this be connected to Beau Brummell strolling out in public, presenting himself as a walking artwork, embodying another kind of lifestyle? Oscar Wilde's unsettling epigram that being natural is a pose isn't too far away. Consciousness makes artifacts of us all. And so does the gallery, the transforming powers of which increase as modernism declines. The spectators in the late-modernist gallery are somehow artificial, aware of being aware — consciousness quoting itself. Though time in the white cube is always changing, the space gives the illusion that time is standing still, as if on a pedestal. Samaras's gesture comments on the aesthetic standards in operation in the 1960s and relies on the vast increase in the gallery's transforming powers. It exemplifies one of the forces that "artified" the empty gallery: collage, and the extension of collage into objects as massive as this studio transfer.

The studio (the agent of creation) is inside the white cube (the agent of transformation); the gallery "quotes" the studio it contains. In the empty studio, one searches for the artist. In the gallery, the artist, when present, is an embarrassing piece of mobile furniture haunting his

or her own product. Indeed, one of the primary tasks of the gallery is to separate the artist from the work and mobilize it for commerce. Both these enclosed spaces are emblematic of the missing artist who, having donated to them special powers, sits apart like James Joyce's artist, paring his nails — or perhaps gnashing them.

Samaras reminds us that it is the artist who generates his or her own mythology, which is then donated to the studio, which becomes, for the public, the mysterious locus of the (potentially subversive) creative act. The artist's myth depends on how the artist is perceived, how the artist lives, and what kind of work he or she produces. It presumes the presence of the lumpen mass that is the artist's indispensable foil — the bourgeoisie, about whom Baudelaire spoke so presciently in his preface to the Salon of 1846. For the bourgeoisie, according to one scenario, consigns its alienated imagination not only to the artist, but to the magical space where art is pondered and brought into being.

The space in which the artist thinks is thus a thinking space, a double enclosure, reciprocal, self-referential, compressed, the round skull in the studio box. This doubleness enhances the rhetoric of both the artist and the studio in a shimmer of signs and synecdoches: the studio stands for the art, the artist's implements for the artist, the artist for the process, the product for the artist, the artist for the studio. All of which avoid dealing with the difficulties of art. This self-referential circulation has, in my view, an effect on the development of the self-referential work of art and the closed aesthetic systems of late modernism.

The creative act itself, or its metaphorical incarnation, can be transferred to the gallery. If the artist — and by inference the studio — stands for the creative process, that process can be relocated to the gallery and made

literal. In Vito Acconci's <u>Seedbed</u>, one of the sights 2, 3
of New York when it was shown in 1972, the unseen artist
lurked under the tilted floor of the Sonnabend Gallery,
where his declared program was to masturbate for the
duration of the exhibition — a formidable declaration of
stamina. We are a long way from Renoir saying he painted
with his cock. Acconci, the transplanted creator, was
engaged in parodying the act of artistic creation, thus
discharging its mystique, which had became a bourgeois
fetish. The complexities of this metaphor sprayed
out in numerous vectors — not least of them the self-
referentiality of the act itself. Acconci also brought his
own studio with him, his own body. For a brief time
the body became the "canvas" on which artists in
places as far apart as Vienna and Los Angeles inscribed
their gestures.

This is the first of the points I want to make. The
displacement of attention in late modernism from the
artwork to the artist, whose creative act focuses on
him/her a mythological apparatus, eventually applies also
to what what Alice Bellony-Rewald and Michael Peppiatt
call "imagination's chamber" — the studio.

Spaces obtain their meaning from social agreements,
confirmed by usage, which can change. Implicit in each
studio is an ideology derived from that agreement. So we
can "read" studios as texts that are as revelatory in their
way as artworks themselves. There are four celebrated
stations in European art where the studio becomes a
manifest subject, each with an increasing consciousness
of the studio space, each with a different social agenda:
Jan van Eyck's <u>Arnolfini Wedding</u> (1434), in which the
artist is an animalcule reflected in the mirror's bubble;
Velásquez's <u>Las Meninas</u> (1656), where he gravely
studies you from behind the canvas; Vermeer's <u>The Art</u>

of Painting (1666–73), usually known as The Artist in His Studio; and Courbet's The Painter's Studio (1855).

4 In Vermeer's painting, we become acquainted with the ornate back of the artist, which both facilitates and forecloses our vision. We peer over his shoulder into a well of light — and silence. The artist is formidably present but unknown. His back is as mysterious as the back of a canvas. If we return to 1666 and withdraw to the unseen rear of the room in which this painting is being made, we see another back, that of the artist painting his depicted Other, who is himself. We are on the threshold of an infinite regression.

The artist painting himself painting is a curious closed cycle. He presents himself as the medium through which the work is realized. As time goes on into modernism, the artist as medium is translated into the medium itself, paint, which thus may be seen as the metaphorical substance of the artist's body. Paint in modernism becomes a quasi-mythical secretion, almost a generative

5 ejaculation, consonant with the habitual sexism of modernism. (Pollock urinating in Peggy Guggenheim's fireplace is a rude parody of this.) As with the ejaculatory discharge, paint is the vehicle of transcendence. Or to be less Freudian, paint becomes a kind of heroic substance engaged in "transformation," one of modernism's alchemical tropes. Paint as an idealized medium is a successor to the symbolic representation of the painter's means in classical art, of which Chardin's

6 The Attributes of the Arts (1766) is one of hundreds of possible examples—the artist's tools standing for their product, art. The gap between the two implies the missing artist, not unrelated to the implications of Samaras's transplanted studio.

7 Courbet's Painter's Studio is a manifesto summarizing, as he put it, the "moral and physical history of my studio."

8

In this metaphorical extravaganza, Courbet materialized
a set of ideas issuing directly from the hero at the
easel, himself. In the long history of the studio picture,
Courbet's may be the first major formulation of the
radical nature of this privileged space. Courbet's cast
of characters, deployed in an extended frieze, testify to
his social concerns and his aesthetic beliefs, attended
by a muse who has become a mere model. On the easel
is a mild pastorale, which Delacroix thought spatially
ambiguous, "as though there were a *real* sky in the middle
of a painting." Above this imperfect but extraordinary
picture, which seems to be painted with powerful thumbs,
is a vague space that "listens" to the hubbub of ideas
below. It is not so much a question of the pictures
that can be made in this studio as of the thoughts that
can be thought there. Indeed, Courbet provides one
of the first modern texts for the relation of studio to
exhibition space. Not too far away was the pavilion he
created to show his own works rejected by the Salon of
1855. About how he conceived that exhibition space, we
have little information.

If Courbet was sending us a message with this
representation of his studio, the message is socialist,
the compassion hearty, the egotism magnificent, even
obtuse, the witnesses on the right unimpeachable, the
emblems of oppression on the left irreproachable. This
is the first picture that argues in a modern, political
manner that the brush may be mightier than the pen. For
what we have here in terms of characters and the issues
they stand for is a Balzacian novel in potency, generated
by an omnivorous mind of great force and confidence
but of erratic subtlety, as we watch the two groups of
different moral weights balanced around the central
fulcrum of Courbet ("I am in the middle, painting"). In
his history of Romanticism, Hugh Honour has pointed

out how different this radical apotheosis of the studio
is from the establishment studio, which is smoothly
continuous with the social order outside. For example,
8 in one of several paintings of Eugène Giraud's studio by
his brother Charles, from around 1860, we see a place
where a bourgeois visitor could come to confirm his
values. On the left in the Courbet painting, in contrast, is
a depiction of that irritant to natural curiosity: the back
of a canvas, which, with time, becomes a subject in itself,
9 as noticed by both Jasper Johns and Roy Lichtenstein.
The anonymous back demands disclosure as urgently as
Christo's wrapped objects. There is an analogue here to
reading. When we see someone reading a book, we want
to know what they are reading. When someone reads a
letter in a film, we urgently want to see it. What is on the
front of the canvas that presents its blind back?

In visual art there is a history of *noticing*. Or rather
a history of making visible what has been seen but not
looked at. I suppose the same distinction can be made
between hearing and listening. Ideas determine what
we see, so new ideas seem to materialize subjects out
of thin air. The studio is such a subject. We can ransack
the nineteenth century — the century of the studio as
subject — and discover every variant: the studio as social
center, as incubator of new ideas, as revolutionary cell,
as church of a new religion, as tradesman's workroom, as
conventional enclosure of received ideas, as home of a
cult, as production factory (including display of product),
as clinical, clean kitchen, as chaotic attic, as site of
experiment, as lair of the solitary hero.

Delacroix painted two pictures, one of which
unpretentiously helped invent the studio as a subject,
the other of which mythologizes the hero in his studio.
10 His Michelangelo in His Studio (1850) is the visual
correlative of the power of mind — the brooding eye,

the lowered brow, the artist sprawling in a postpartum pose of meditative withdrawal. According to classical rhetoric, great minds make great bodies (in the case of Michelangelo's figures, vice versa). Michelangelo's Medici Madonna, depicted on the right of the painting, signifies the workshop, the thinking space around the thinker inside. A set of conventions is summoned to invigorate a Romantic cliché. As with all inflations of a bourgeois idea into the heroic, it is deflated with a glance. Delacroix, of heroic stature himself in his youth, attempts to advance through a doubtful rhetoric something in which he deeply believed: the power of the imagination. So empowered, art can transform the world — or such was the utopian prospect. It was no coincidence that the two overarching heroes of the nineteenth century were Shakespeare and Michelangelo.

Yet in his own studio, Delacroix, in 1855, glances at the stove in a corner and, in a secular act of more authenticity than his Michelangelo, depicts it, and in doing so, records the studio's most durable inhabitant—apart from the artist: the mundane stove. Perhaps no more abrupt contrast than this can be imagined between high-art rhetoric and what you might call vernacular perception. Delacroix's corner is as frugal as a night watchman's. It is, to my mind, as much invention as depiction insofar as it recognizes an ignored subject, indicating the growing consciousness in the nineteenth century of the studio as subject. This is one of those welcome occasions when a major artist recognizes the value of the unimportant and ignored. The work begins with observation and, through the alchemy of paint, ends in transformation. Delacroix's corner, like its diverging walls, goes in two directions —toward academic descriptive prose and toward radical observation of the banal, most usually associated with Impressionism, in which the unimportant subject,

something noticed between events, as it were, becomes the source that, when depicted, makes the paint — but not the subject — the hero. Paint as medium and the artist as medium begin a curious mirroring.

In representations of the studio, we gain access to privileged spaces. Studios and lofts are messy with the detritus of their means. Such detritus becomes not just noticeable, as with Delacroix's corner, but a theme with an agenda. In 1967–68, a New York artist, Lowell Nesbitt, went around with a photographer to the studios of his colleagues. Like a film director, he pointed out to his photographer what he wanted photographed. He didn't touch anything or ask for anything to be rearranged. Sensitive to his own trade, he felt the studios were "portraits of the artists without their faces and bodies," a comment implicitly critical of the artist-in-his-studio 12, 13 cliché. If we compare the photograph of his own studio with its painted representation, there has been some tidying up, but everything remains in its right place. He has included the paint splatters on the wall that are spinoffs of process, creative residues, or art-in-potency. Indeed, such is our artifying habit that with a little ingenuity we donate aesthetic value to these residual splatters. I say art-in-potency thinking of the well-known story of the artist Yuri Schwebler going around Sam Gilliam's studio in Washington, D.C., collecting bits and pieces of paint-stained canvas from the floor and exhibiting them himself as art. In Nesbitt's painting, the artist's clothes, spread-eagled against the background, stand for the artist who stands with us, painting and looking on (clothes make the missing artist).

14, 15 Among the studios Nesbitt visited was Louise Nevelson's. Is her studio "a Louise Nevelson" in that objectification of personality-as-product that has become our filing system for the notion of originality? Nesbitt

also visited Claes Oldenburg's studio, where the mess 16, 17
he recorded was, as in all Nesbitt's work, cleaned up a
bit, slightly idealized, but informed by a determination to
keep everything exactly in place. This idea of the mess
would extend itself to the gallery in the development of
another genre — the distribution and/or accumulation
piece spread on the floor, which would become as
sensitive as the surface of the canvas after the pedestal
— sculpture's "frame" — had melted away.

For now, with Nesbitt and others, the artist is gone.
The studio has become the artist *manqué*. The creator
is an intruder in his or her own space, and returns
only with various excuses and disguises, as in Jasper
Johns's study for <u>Skin I</u> (1962), where the missing artist 18
(from within) presses his face against the window of
the picture plane/studio, leaving only smudges of his
presence. Johns's art is, of course, full of references to
the missing artist who returns in bits and pieces, his
studio "wall" retaining marginal strokes and tests, bits
of stilled process. As residues, they are what we might
call para-creations, footnotes to the departed painting.
In this disabling ambiguity in the artist's perception of
himself, no wonder the studio, the apotheosis of process
and means, takes on more solidity. For one who has
transferred his identity to the medium, who has identified
biography with process, and process with studio, there
is little opportunity to return from exile. In a situation
where every assertion is tinged with doubt, where the
relativity of every statement must be precisely explained,
the author lurks and shuffles around like a vagrant, denied
entry to the formal paradise he has created. Cubism,
Constructivism, Expressionism, even Surrealism all
ultimately fictionalize the missing author. They fill the
void with the myth of the artist, the public's stabilizing
frame of reference, perhaps the public's revenge.

Implicit in the secular fragment of Delacroix's studio is the idea that the Romantic imagination can only be incubated in surroundings of poverty and isolation. This underprivileged space has a history, from the young English poet Chatterton writing in his garret, to the fictitious *la Bohème*, to the Bateau-Lavoir in Montmartre, to early SoHo. Early modernist studios, from what we see of them in photographs, have a functional rawness. Like photographs of early performance works they are unconscious of posterity and are generally furnished only with the essentials of art-support and life-support, including the ubiquitous stove. When caught by the camera, these frugal spaces have a rather startled air, like Picasso's Bateau-Lavoir studio in 1908. They do not yet know they are historical documents. But they are the beginnings of the arc that ends with the celebrity artist in his celebrity studio, one of late modernism's dominant fetishes, which domesticates the studio as a source of radical thinking and to some degree compromises the art that issues from it.

The movement that made a fetish of fetishes— Surrealism—emphasized the magic nature of the beast inside the studio, forcing out of the congress of objects a language that had not been seen or heard before. From the Surrealist studio came dreams of social reform based on anarchy, which frequently declined into mild diabolisms, as in Max Ernst's presentation of himself. Artists like the Surrealists and their Romantic predecessors were heirs to what Rudolf Wittkower describes in *Born under Saturn* as the proto-Bohemians of the 1540s in Florence: "...a new type of artist emerged with distinct traits of personality. The approach of these artists to their work is characterized by furious activity alternating with creative pauses, their psychological make-up by agonized introspection, their temperament

by a tendency to melancholy; and their social behavior by a craving for solitude and by eccentricities of an endless variety." Eccentricities indeed, echoed by the Abstract Expressionists and Surrealists, who, as Lee Krasner reported, competed by dressing up their women in bizarre costumes for parties, like poodles on display—a sexism that runs through modernism, also exemplified by the female model in the studio.

The studio as a cultists' club, where a group sets itself up to live, commune with a leader, practice what is unconventional to the popular mind, and manufacture art for the fools who want it, is close to a description of Warhol's ironically named Factory, first located on East 47th Street in New York. There the cult leader, dandified, seemed to hover in idle suspension, a posture refuted by the flow of product to the outside. It would need Roland Barthes to describe Warhol's face, a neutral mask that [21] could accommodate any reading. Warhol's early persona —the silver fetish, silver hair; the walls of silver, light gliding, coruscating, fracturing in an unsettling dazzle— was a marvelous conceit. To work without appearing to work, to be a passive Svengali who held others entranced, so that, nourished by doses of irony and sometimes danger, they believed that everyone outside the group was clumsily comic—that was the quasi–Manson-like character of the artistic cult, which is always a cult of personality. All this ended when the silver carapace was penetrated by the madwoman's bullet. After that, [22] Warhol's cult was different. He could pose as someone already dead, patiently suffering the tedium of the afterlife. Warhol's persona, a brilliant construct, has not been sufficiently appreciated. He made the role-playing of the disco intersect with the studio in a dream of luxury [23] and surface. Advanced art made easy.

15

We might see the extremes of 1960s studio culture in New York as represented by Warhol and Rauschenberg, contrasting the former's flat ironies with the latter's Whitmanian exuberance. The mystique of Rauschenberg's cult was movement, activity, surfing on the *Zeitgeist*. From 1961 to 1965 Rauschenberg had an omnivorous appetite, as if his studio were a vast stomach digesting twentieth-century media glut. Through the silkscreen, he and Warhol could bring any subject to heel. At that time, Rauschenberg pursued a utopia situated in the "now." Like many American constructs, this utopia had an imperfect knowledge of evil, a disbelief in its presence and powers, which survived even the Kennedy assassination in November 1963. The performances, the art and technology wonders, the dancers gliding in and out of the studio, the open house at Lafayette Street (where a huge wooden airplane occupied one room), the artist's chronic generosity, urged a generation of dancers and artists on. Remarkably, few of those in his charismatic aura made work that looked like his.

Rauschenberg's studio was a kind of commune, its spirit a radical innocence. It inherited the tradition of the studio as a social center, a place where ideas about art and dance overlapped with a utopianism like that of Brook Farm, the Massachusetts commune of the 1840s which aimed, as its founders stated, to substitute a system of brotherly cooperation for one of selfish competition. Rauschenberg in his arbitrary, charismatic way joined art, science, and dance with collectors, money, business, and magazine and newspaper culture in the amiable promise of immediate gratification. This democratic federation of diverse interests was one of the most extraordinary social creations of the 1960s. At its center was this kinetic, extroverted creature who seemed to embody Blake's "Energy is pure Delight." Money flowed, outer space

was being domesticated, the young were dancing to a new beat, drugs and sex promised transcendence, the slogans were peace and love. Altamont was in the future. It seemed as if consciousness itself was being redefined. From Rauschenberg's studio came one work that perhaps summarizes the glorious confusion between art and life: Bed (1955). Let us follow that artwork as it tumbles [24] genially between studio and gallery.

There are some profoundly intimate spaces. The inside of a shoe perhaps. Or the mysterious inside of a woman's purse, which calls for its Bachelard. Another is the bed. Like the studio it is soaked with the personal; even when empty it crawls with imprints and residues of identity. It puts on the same horizontal plane the tortures of sex and the ecstasy of dying. The bed is the nocturnal baseline of our vertical endeavors. It seems to exert an extra gravitational pull. Heavy with sleep, we are weighed down into some archaeology of memory and forgetfulness until we are made weightless by dreams or exploded by nightmares. The act of raising this horizontal familiar, like Lazarus, from its prone position to the vertical lets loose on it, in a violent rush, the powerful aesthetic conventions of looking at a picture on the wall. We still pick up shockwaves from this vertical bed. The gesture (it is as much gesture as painting) takes an indispensable part of the studio lifestyle — the bed in the corner, the locus of our nocturnal return — and embalms it in the paralyzed time of the white cube. The all-over tactility of the ensheathing bed in the studio is transferred to the exclusively visual, no-touch gallery. The passage from studio to gallery of one of the studio's basics (bed, table, chair, easel, stove) invites comment on the linkage between the loci of generation and display. In "The Function of the Studio" (1979), Daniel Buren was the first to ponder and write about what he called "the hazardous

passage" from the studio (where he considered the work to be in place) to the gallery/museum, where placelessness isolates and reifies it. Rauschenberg's Bed, a kind of sarcophagus, slides both together in such a perfect overlap that its raises the thought of a return journey — back to the studio again, where another bed has now replaced it.

How would Rauschenberg's bed look if it were returned to the studio? How did the painted bed look in the studio both before and after it was attached to the studio wall? It would not be alone. The studio is more or less crowded with artworks, periodically depleted as they migrate to the gallery. Artworks lie around, parked, ignored in remote corners, stacked against the wall, reshuffled with the cavalier attitude allowed only to their creator. As one work is worked on, the others, finished and unfinished, are detained in a waiting zone, one over the other, in what you might call a collage of compressed tenses. All are in the vicinity of their authenticating source, the artist. As long as they are in his or her orbit, they are subject to alteration and revision. All are thus potentially unfinished. They — and the studio itself — exist under the sign of process, which in turn defines the nature of studio time, very different from the even, white, present tense of the gallery.

Studio time is defined by this mobile cluster of tenses, quotas of past embodied in completed works, some abandoned, others waiting for resurrection, at least one in process occupying a nervous present, through which, as James Joyce said, future plunges into past, a future exerting on the present the pressure of unborn ideas. Time is reversed, revised, discarded, used up. It is always subjective, that is, elastic, stretching, falling into pools of reflection, tumbling in urgent waterfalls. When things are going wonderfully well it stops in a fiction of immortality.

Or it may decay into a tizzy of impotence — as Ingres is supposed to have suffered when precision eluded him — or toss the artist around in a frenzy. In the midst of this temporal turbulence, artworks in the studio have an alertness, no matter how casually thrown around, that they don't take with them when they leave. In the studio, partly as a consequence of this, they are aesthetically unstable. Accompanied only by the artist (and occasional visitors, assistants, other artists), they are vulnerable to a glance or a change in light. They have not yet determined their own value.

That begins when they are socialized on the gallery walls. If the artist is the first viewer, the first stabilizing factor is the studio visitor. The studio visit became a trope in modernism, and remains so. The visit has its etiquette and comic misunderstandings. The studio visitor is the preface to the public gaze. The visitor brings an environmental aura — collector, gallery, critic, museum, magazine. The studio visit can be a raging success or a disaster, a much desired "discovery" or an intrusion from hell. My favorite is Bernard Berenson's description of his visit to the studio of a barely civil Matisse. There is no better illustration of a sublime philistine (toward modernism) visiting a great modern artist. The art puzzles him. He wonders about Matisse's reserve. His thoughts as he reports them would set any artist's teeth on edge. Matisse says little. Berenson leaves, one of the great art historians — along with Gombrich, Kenneth Clark, and Panofsky — to whom the modernist adventure was a wilful and misguided anomaly.

By now, we are aware of the fields of force, as it were, that surround the artist in his studio, whether it is the studio of accumulation or the studio of monastic bareness, which, according to Ernst Kris, descends from Plato

through Christian saintliness. Why these extremes? Is it just a matter of housekeeping? If the studio reflects the mind of its occupant, is one mind an attic, the other a prison cell? Does one introduce us to the aesthetics of redundancy, the other to the aesthetics of elimination — the glutinous studio of ingestion and the anal studio of excretion, the fat and the slender, Laurel and Hardy seeing each other in the studio's distorting mirror? Are studios of accumulation indubitably secular? Do studios of elimination have a yearning for some absolute? Does each indicate a temperament and an aesthetic?

A perfect example of the studio as accumulating

26 artwork is Schwitters's Hanover <u>Merzbau</u>, begun in 1923. The artist, like some industrious organism, shed his own exoskeleton as the studio progressively evicted him and limited his visitors to one entry at a time. The agent of the process was compressed by his own crowded studioscape. The studio became a proto-museum as Schwitters worked inside, "wearing" his studio, trying it on for size after every addition or change. Such studios of accumulation have had a didactic, even legendary value with respect to postmodern gallery installations that stuff and insult the white space. As proxies, they take on some

27 of the aura of their creator. Francis Bacon's studio, in a very different way from Schwitters's, was a cumulative, living collage, a "compost heap," as he called it. In *Imagination's Chamber*, Bellony-Rewald and Peppiatt describe "the floor...ankle-deep in books, photos, rags, and other paint-splashed, eye-catching rubble, while the walls have been so thoroughly daubed with trial brush strokes that they resemble giant palettes." The small room had one window and one door. It was crammed with accumulated debris: a mirror, slashed canvases, canvases with cut-out centers, encrusted pots of paint, brushes, tubes, patches of bare wood wall (when not

covered with photographs), pages torn from magazines, a book on Velásquez, postcards of artworks. No bed, no sink. This version of chaos, however, still had its memory. It was living memory, from which Bacon retrieved the photographs and reproductions that contributed to his paintings. The redundant mess had a reassuring function for the artist. It was a "womb" within which he could work, perhaps signified in his paintings by the skeletal cubes which trapped many of his figures.

Every studio has to have some traffic with the outside. In Bacon's case it was not only photographs and reproductions. It was words. Magazines and books were ingested and digested in that small room. The processes of reading, looking, thinking, painting, destroying, were superimposed one on the other with the energy of a consumer who tested everything by one criterion: could it be used? Now preserved in Dublin's Hugh Lane Gallery, Bacon's studio carries such a whiff of presence that you can hallucinate the large, restless, reputedly dangerous animal inside as you peer through door and window. What happens to this room when it is frozen in museum time? How does it illuminate Bacon's art? It becomes emblematic, circulating a low-grade energy among artist, persona, studio, and work, enough to sustain the myth it begot.

Few experiences were as mythopoeic as visiting Mark Rothko's studio on East 69th Street in Manhattan. Easel, a couple of chairs, a scruffy couch where he frequently slept, especially toward the end, huge frameworks, a skylight with adjustable drapery to filter and change the light, racks of drawings and canvases, a table — and the uneasy occupant, the artist himself. Rothko's studio, in contrast to Bacon's and to that of the fascinating nineteenth-century American artist Albert Pinkham Ryder, was bare, functional, puritanical — a *studio*

povera indeed. His high seriousness dismissed everyday trivialities and discomforts.

What made a visit so testing was the hypersensitivity of its inhabitant, who was engaged in superimposing, through the finest of micro-decisions, the nineteenth-century quest and the modern void. In that dark studio Rothko seemed as much the victim of his work as its creator. The more he succeeded in his mission, the more he seemed excluded from his own product, as if he could reveal the secret but not share in it. The studio seemed to enfold a great, unmentioned secret. This was a source of irritation and perhaps rage. There was a flow of quiet visitors, many of whom found the experience tense. As they looked at the work, Rothko would fasten his gaze on them. He would decipher, or thought he could decipher, any hint of approval, disapproval, puzzlement, even scorn. One innocent was thrown out because, Rothko said, "he did not respect the work." Knowing that respectful young visitor, I was mystified as to how Rothko came to that determination. The high, shadowy studio seemed a preface to transcendence, an ambition easily mocked but, as it turned out, deadly serious. The windows looked out on nothing in particular, but the light from them and from the skylight was coaxed to deposit itself in a crepuscular vibration on the dark canvases. As you sat watching with Rothko, the light slowly waned, its changes barely perceptible, until the edges of the painting blurred into the dusk, something he accepted with pleasure. The gallery's more stable lighting was unwelcome to him since unchanging light deprived his paintings of their variety of moods. The paintings looked better in the studio. Their vulnerabilities echoed Rothko's sensitivities. There was something of Balzac's Frenhofer about Rothko — both artists engaged in an impossible task in the mysterious studios that witnessed their demise.

How different was Duchamp's amiable exhibition of an empty studio, presented in his later years as evidence that, as he announced, he had given up art. Of course, no one knew that in another studio he was finishing his last major work, the Étant Donnés. The Duchampian paradoxes are comical. The empty studio, the site of production, is displayed as evidence of nonproduction, a mask for an activity in process elsewhere. A creative gesture—the invention of an empty studio—is presented as evidence of sterility, the paralysis of the creative act. Duchamp, whom no one saw working, was practicing a secretive art in a secret studio —appropriately, since Étant Donnés, the work that emerged, reduced the visitor (spy?) to a scopophilic stare through an eye-hole. [29]

The frugal studio, stripped bare of everything but what makes a painting, has its supreme nineteenth-century text in Georg Kersting's famous depiction of Caspar David Friedrich in his studio, of 1812. This picture exerted a hypnotic fascination on Friedrich's contemporaries, including the painter Wilhelm von Kügelen. "Friedrich's studio," wrote von Kügelen, "was absolutely bare...there was nothing in it except an easel, a chair, and a table. A solitary ruler was the only wall decoration. No one could figure out how it had attained that honor. Even the necessary paint box with its oil bottles and paint rags was banished to the next room, for Friedrich felt that all extraneous objects disturbed his interior pictorial world." This archetypally reductive studio contained only the executive essentials—artist, paints, canvas, easel. His colors, as in Kersting's depiction, are set out carefully on the palette; the brush, tipped with blue, hangs from his hand (he's right-handed). Everything certifies its own presence through bare necessity. Friedrich has just gotten up from the chair over which he leans to see his [30]

work from a little distance. He's muffled up; is it cold? (Rumor has it he was naked underneath.) He casts on his work in process that Romantic eye we know from his 1810 self-portrait. The myth of the artist as unique creature, which Friedrich undoubtedly was, is embodied here. The stripped-down studio, the inspired painter, the concentrated gaze charging the space between eye and canvas, which keeps its secret by presenting its back.

But this is not the painter painting himself painting, the closure of a quasi-narcissistic cycle. It is another artist, Kersting, who paints, in the process observing Friedrich interrupting his process with meditation. What is the effect? The artist Kersting painting the artist Friedrich pausing and looking turns the process of painting back into itself and thereby doubles it. One process is enfolded in the other, since Kersting is practicing what he depicts. It is a short step from honoring the process of painting, here in its Romantic excursus, to honoring process itself, and from there to the artwork in which process is stilled, embedded, held in potency, and from there to the general notion of art's self-reflexivity, which Heinrich Heine in 1837 called "the autonomy of art," later celebrated by Lionello Venturi — leading, in a teleological slalom, to the self-sufficient artwork in the isolated white cube, one of modernism's climactic inventions. This is the second point I want to make: the connection between the self-referential creative process and the autonomous artwork in the gallery. The increasing autonomy of the artist, now a magic beast in his studio shell, eventually transfers itself, particularly with the invention of abstraction, to the artwork enshrined in splendid isolation in the white gallery.

In Kersting's studio picture, the doubling does not stop with the doubled process of painting, one inside the envelope of the other. Friedrich believed that art was

24

the result of a negotiation between inner and outer; the thing seen echoes in some mental chamber within and is returned outward to transform what is seen. "Close your bodily eye," he wrote, "that you may see your picture first with the spiritual eye. Then bring to the light of day that which you have seen in the darkness, so that it may react upon others from the outside inward." When the artist "sees nothing within," according to Friedrich, "then he should also refrain from painting what he sees without." This transaction between outer and inner was mediated through the Romantic eye. Is the studio window the emblem of this? Inside, the thinking studio; outside the quotidian world going about its business.

The window—a perfectly divided square nicked by a corner of canvas—invites the glance to the outside. A window parallel to the picture plane is an inner frame, which reciprocally frames the actual frame. Framing, like the Claude glass, invites the looker to project his or her aesthetic system into what is framed. The window within frames a quota of "reality," an illusion within the illusion, whether it's the toy towns of Flemish art or the suave flattening of space in one of Matisse's [31] windows, where the opposition between inside and outside is lessened and made almost continuous—a dazzling piece of coloristic legerdemain, as is, indeed, his classic representation of the studio in modernism, the famous Red Studio (1911), in which the art depicted exists [32] in the fullness of color while the furniture exists as diagrammatic ghosts.

The opposition of the two continents of inside and outside, common to all cultures, is particularly potent in representations of the studio window—so potent, in fact, that Friedrich too made it his subject. The view through [33] the window of his studio (1806)—not the same studio depicted by Kersting—is oblique, quietly unsettling what

25

is seen. The sidelong glance offers not so much what the window frames as the act of looking, a subject to which Friedrich returned again and again, as in his <u>Woman at the Window</u> (1822), where he shows us the woman's back; in yet another doubling, he places the spectator within this picture, as he frequently did, inventing an aesthetic of the back as surely as the back of the canvas was to become a minor note in modernism. The blind back relays our gaze outside to what we cannot see, to what is assumed to be there, to something virtual. The back becomes a sign for vision. It stands not so much for what the figure sees as, again, for the act of looking.

However we look at the closed or open window — as an eye, an umpire of inside and outside but partaking of both, a labyrinth, a magnet, a membrane, an illusion, a lens, an escape, an internal frame, an opacity, an aesthetic system — it is always, in my view, most certainly a plane with length and breadth but no thickness which mimics the potency of the empty canvas. The studio window, adjudicating the dialogue between the art chamber and raw "reality," is emblematic of the creative process in whatever configuration it may declare itself. Passage through a door involves a subliminal shudder of adjustment as one space is exchanged for another — the bedroom, say, for the kitchen, or the vast space outside for a room within, which is always a site of expectation, confirmed or not. The passage of the glance through the window, from enclosure to limitlessness, implies, in my view, a similar, if more subtle, exchange. Lorenz Eitner calls the window "a threshold and at the same time a barrier" in his famous essay "The Open Window and the Storm-Tossed Boat." "Through it, nature, the world, the active life beckons, but the artist remains imprisoned, not unpleasantly, in domestic snugness." He goes on to quote Schlegel, who contrasts "the poetry of possession"

—the intimate interior—with "the poetry of desire"—the tempting spaces outside.

Eitner finishes his commentary on painters of the open window: "[The subject] seems to have appealed especially to artists whose outlook wavered between romantic and classicist attitudes, and there certainly is significance in the fact that the window-view came to prominence again, much later, in the Epicurean, Neoromantic work of Bonnard and Matisse." Can we compare the blinded window to the late-modernist painting? From its ultimate flatness the gaze bounces back or slides to the edge, and beyond to the wall, which becomes an aesthetically active zone. Perception is telescoped into the late-modernist glance, which could scan an exhibition—particularly of late abstraction (Color Field comes to mind)—in a few minutes, clocking off sequential epiphanies in what the 1960s called the "wow" experience. Perception was instantaneous and complete.

The liberating act of "looking out" has its reciprocal twin, the act of "looking in," with connotations of illicit observation, of scopophilia, of narcissistic empowerment. Voyeurism, one of the most powerful of human instincts, does not appear in our context; I know of no depiction of the view looking in through the studio window. This is so even though the creative process is generally a secret activity, and secrets ask to be revealed. Looking, however, is the favored subject of one American artist, Edward Hopper, for whom that curious participle perfectly conveys, as participles do, a continuous, sustained action—"basically having," as the dictionary puts it, "the qualities of both verb and adjective." Participles are also, perhaps, a little nounlike. "Looking" therefore can compress within itself process, description, and stasis. Hopper's disembodied eye precedes the viewer through windows, often facing other windows, which

35

27

invite, mirror, return, and redirect the gaze in a complex game of ricochets before going to ground, leaving us alone with his subject, frequently solitary women, who themselves may gaze through windows, convinced they are alone. Hopper subsumed the voyeuristic impulse in a magisterial gaze which has a deliberate pace and tempo, frequently involving delay. His paintings propose an etiquette of looking. A gaze which, when looking at women, does not mythify them. They are not enhanced by desire, nor compromised by the male impulse to degrade, even though the women often look like tough broads. His gaze summarizes the modality of "looking," which in turn implies the absence of a prejudiced observer, who is replaced by a disinterested abstractness of vision. In cultivating this, Hopper's windows are surrogates, stations, mediums, signs, signifiers.

36 In 1916, Matisse painted a picture I take as a touchstone for four themes. The painter is studying a painting of the model, who reclines to the right, the open window to her left. Four themes: the painter, the window, the canvas within, the model. Perhaps one of these stands, as much as the artist does, for the conversion of nature into art: the model, early modernism's handmaiden, who became, shall we say, indispensable livestock. (Courbet's short-lived school comes to mind, where students solemnly studied a cow.) The model was overwhelmingly female and, with Romanticism, became not just a secular figure but a muse, a passive collaborator, who, according to Kris, signified the artist's sexuality; he cites the Actaeon and Galatea myth as a reflection of the artist's desire to create living creatures rather than a simulacrum *à la* Kokoschka and his female mannequin. There is a succession of famous models in modernism — from Courbet's Jo Heffernan (also shared by Whistler) to

Manet's Victorine Meurent to Man Ray's Kiki to Picasso's women — all of whom were ushered out the studio door with the triumph of modernism's most pedigreed product: abstraction.

The nude as muse, naked to the male gaze, also modeled the capacity of women to invert themselves into a kind of echo chamber for male desire. That desire was sublimated in the locus of creation, the studio, which was now a gendered space, the womb that delivered the work. In the 1950s "the creative act" became a popular fetish that exonerated the spectator from the travail of engaging the work itself. The mystery of the work was displaced to the mystery of its creation, which remained comfortably indecipherable while draining its subversive energy. The artist painting the model in the studio was, however, replete with paradoxes that played around this cliché of the creative act.

The artist's creative act has a well-established rhetoric: the ecstatic insemination with an idea, the birth of the work, the difficulties of process, the exhausted *auteur*. A peculiar sexual exchange is going on here. For this is the language of *accouchement* — the labor of the woman. What inverse sexism! The woman's mode of reproduction is taken as the analogy of male creation. Or is it, charitably, the attempt of the male to share in that mysterious process of birth from which he is excluded? For if it is through the model that the artist delivers the work, could we not say that the female model inseminates the male artist? In this scenario, the great sexist Picasso would take on the woman's role. The fertility of the model would extend to the studio itself, a space repeatedly inseminated by the congress of male artist and model. Through the creative act, our ideas of sexual roles and of art-making flow back and forth with great instability. The key point is the way in which creation becomes

29

attached to the studio itself, the first context of transformation. Cluttered or bare though it may be —chaotic mess or saintly retreat—it is its fecundity that is its prime identifier, and process its signature. We can extrapolate from the fecund model to the studio's generative womb. Although, at times, matters may be

more comically banal: in a wonderful photograph taken in Nice in 1928, a model glares at an unaware, buttoned-up Matisse. Is this the model's revenge?

The model was an indispensable adjunct of high modernism, as codified by Matisse and Picasso. Models are scanty with Braque, who continually found inspiration in the studio itself, and whose late predominantly black and white paintings of the studio are among modernism's somewhat neglected triumphs. He returns us to the idea of the studio reflecting its own process, as the creative act dissects itself in the locus of creation. Are there famous American models? Very few. Mostly Pop icons à la Warhol. The era of the model runs erratically and transnationally, from Giovanni Bellini's extraordinary pin-up in a state of abandoned narcosis in the lower right corner of his Feast of the Gods (1514–29) to Picasso's promiscuous cruelties. And as with Hopper, the question always at issue is the nature of that icon of feminist theory, the male eye, which, in terms of artist and model, is an analogue for seeing as touching—the caressing gaze, the sly glance, the lubricious look, the acquisitive glare, the penetrating stare.

In her brilliant essay "Visual Pleasure and Narrative Cinema," Laura Mulvey tagged two modes of cinematic observation: the narcissistic identification with what is seen, which she calls a function of the ego libido; and the "pleasure of using another person as an object of sexual stimulation through sight," which involves "the separation of the erotic identity of the subject"—that

is, the looker — "from the object on the screen," or shall we say, the painting, or more precisely, the model in the painting. She makes the point that when the gaze of the latter pleasure-seeker consumes its object in a film, usually close-up in filtered voluptuousness, narrative sequence is interrupted. The stoppage in time is sustained by a cycle of attention between object and viewer. In painting, the female nude is the equivalent, I suppose, in terms of its magnetism for the male gaze. Painting favors Mulvey's second mode of observation, pornography her first, though I wonder how many study the landscapes behind Titian's reclining nudes, whose gaze holds the viewer, the power of the female gaze being something shared by high art and stimulating trash. A history of the nude in painting would have to indicate changes in modes of idealization and de-idealization, in the conventions of sensual reward and frustration, from Titian's Venuses to Manet's revisionist Olympia and, beyond, to Matisse's *luxe* and Picasso's cannibalism.

Matisse's painting also bought forth within it another picture, in process on the easel, a replica of part of its own space. The painting within, an illusion within an illusion, has a doubled magnetism, like those moments when you see actors in a film watching another film. Both insist on a larger quota of attention than the parent film or painting, and might be seen as psychologically framing the parent. The artwork within, a double illusion, is thus doubly art. If the painting within is art, the rest of the painting (or film) is pseudo-nature, mimicking "reality." Traditional representations of a picture within a picture — for instance, the van Baburen hanging on the back wall of two of Vermeer's paintings or, indeed, the landscape on the easel in Courbet's Studio — also comment on reality, but they remain more reticent than representations of the act of painting, whether Rogier van der Weyden's *Saint*

Luke Drawing the Virgin (1435–40) or Picasso's depictions of the painter drawing the model. Usually, as in Matisse's *Painter in His Studio*, the painting-within-the-painting is on an easel and the context, however depicted, is a studio. We are invited, as spectators, to partake in the creative act. Many of our themes cycle provocatively back: the medium depicting itself, paint used to describe paint, a picture generating its own offspring, the painter painting himself painting a picture.

Throughout this essay, I have referred to the self-reflexive nature of much modernism, its habit of double enclosure, as if protecting itself. But protecting what? The answer would have to be its own exclusive means, infused with the last residues of idealist philosophy. In my book *American Masters: The Voice and the Myth* (1974), I wrote about the fate of two figures in the nineteenth-century landscape: the watcher, so frequently present in Friedrich's paintings, whom I take to stand for mind; and the tiny figure of the artist painting himself painting the landscape. "Toward the end of the century that figure — the artist — disappears into the medium, is replaced by touch and color and process. The figure representing mind also disappears. Its remnants of idealism join with the medium to fill the void caused by its departure, and thus initiate the proper history of modernism" — leading to modernism's dyslexia, to seeing form but not content.

However the painting-in-the-painting shapes itself — almost always as a tilted rhomboid, since it is seen from an angle, top and bottom accommodating the required convergence — it declares the rest of the painting outside it, as mentioned above, to be "reality," a word which Worringer replaced with "actuality," and which Nabokov said should always appear in quotation marks. Indeed, the painting within "quotes" part of the parent painting, inviting the act of looking to reproduce itself.

What the self-depicted artist paints compares his model outside and inside the painting-within-the-painting, thus giving the viewer the opportunity to study matters of reproduction, convention, and transformation. Picasso often contradicts what the artist sees and what he puts on the easel, continuing his comment that art and nature are different things, even in this realm of double illusion.

What if a blank canvas was depicted within a painting? Depictions of blank canvases are rare. But inside or outside the picture, the blank canvas possesses a mysterious potency. As Robert Motherwell said, "I hope I can do something as beautiful as the empty canvas." But the empty canvas is not blank, not a free zone or *tabula rasa*. It is already inseminated with a presumptive complex of implied options. It is occupied territory. What does the painting-within-the-painting signify? Art, of course, but most surely the locus of creation itself, the studio, reenacted within a painted studio. As you might expect, the most cogent epigram on this matter was delivered by Magritte in his series of paintings entitled *The Human Condition*. The painting on the easel within bleeds into the "reality" around it, separated only by the ghostly outline of the canvas. The back of the canvas, the window, the model, the painting-within-the-painting, the painter depicting himself—each contributes in its own way to the definition of the studio.

How has the studio influenced the white cube? Two studios, Mondrian's and Brancusi's, had a great influence. Mondrian had two studios, one in Paris, the other in New 38, 39 York. Both were famous. I would like to have stood in Mondrian's studios, to have seen the home of the "new plastic reality" and the ghost of Madame Blavatsky. A good woman, Nelly van Doesburg, Theo's wife, wrote a perceptive memoir of Piet Mondrian after his death.

Of the Paris studio, she wrote, "It is well known that Mondrian's studio on the Rue du Départ was decorated with the pure colors and geometric severity found in his abstract paintings." By the way, in terms of the excluded (rather than missing) artist, she recalls her husband and Mondrian "executing a painting together with the express purpose that all traces of individual participation be removed." Mondrian's sparsely furnished house in Paris, as photographed in the 1920s, was perhaps more *moderne* than Mondrian. "[W]ithin the artificial surroundings of his own studio," Nelly tells us, "the placement of ashtrays, table-settings, etc., could not be altered for fear of disturbing the 'equilibrium' of the total decor which he sought." The horizontal and vertical were diligently preserved. Indeed, Lee Krasner related that when she danced with Mondrian he "danced vertically" — which was not conducive to wild abandon. Presumably, no diagonal movements were allowed, which recalls the famous "diagonal" quarrel between van Doesburg and Mondrian (Rothko also hated diagonals; the only diagonals he liked were Hopper's). As Max Bill put it, "We have become accustomed to seeing pictures as rectangular planes parallel to the wall limits of normal rooms. Mondrian capitalized on this rectangular perception and made it the basic principle of his painting." "A horizontal-vertical structure," Bill goes on, "accords with a horizontal-vertical environment." Yet, as Bill says, when Mondrian tilted the canvas and stood it on a point in his "diamond pictures," he moved away from these inflexible coordinates.

The discourse of the horizontal and vertical coordinates, intuitively resolved with considerable anxiety, produced "pure plastic reality," one of the last remnants of modernist idealism. Mondrian's art dispensed with what we are pleased to call "the real

world" (eventually — despite his great early tree and pier and ocean paintings, he avoided nature as if it were infectious, which reminds me of Stuart Davis's excuse for turning down invitations to the country because he was "afraid of trees"). As formulated by Mondrian, art became a polemical force in the world outside the studio, but at a price. Ironically, the intense trial and error of his method, his painful discriminations (relationship to edge, width, and number of bands; limitation of color), the madness of his precision, were all decanted away to leave the logical residue called "design." Intuition was reduced to measure, insight organized into system, and systems can be applied to social needs. Art is difficult; systems are easier. Mondrian's art influenced everything from architecture to *haute couture*. His search for the "right" placement became placement as tact, which became taste.

In his last phase in New York, Mondrian was intensely curious about his environment — ideas, jazz (which Stuart Davis explained to him, and which Mondrian then explained back), architecture (though the skyscrapers of New York were "too tall"). But in his studio, no junk around, no books, his letters read and burned — nothing interfered with the coordinates of his idea, except, perhaps, the sweaty organic mess that we are. There is a kind of art that despises the body that produces it. Mondrian's puritanism carried over to the white cube, where the visitor is always transgressive. Whatever interfered with his life was removed; whatever interfered with his art was removed. On the wall, each self-contained painting (and no paintings are more self-contained than Mondrian's) had a defined quota of space around it. How did he judge those separations? He hung his colored-paper squares (based on the work he did around 1920) in erratic rows, groupings that seemed carefully unplanned, sometimes in little constellations.

40

35

He put them anywhere, even using the occluded fireplace.
He kept them away from each other, but not so far that
they forgot each other. Each square remained mostly
a single perception that said blue, red, yellow, white. An
occasional gestalt offered itself. It is easy to see that this
studio was a proto-gallery.

The wall was already a force here, separation and
distance a new language as yet unspoken. Mondrian's
studio was, I believe, one of the factors that influenced
the proud sterility and isolated hanging of art within the
white cube. The white gallery has, in concordance with
Mondrian's angles, sharp corners. No rounded corners
like those of the gallery that Tony Smith designed for
Betty Parsons at 24 West 57th Street; no extravaganza of
flying stairs and water such as Frederick Kiesler designed
for the World House Galleries on Madison Avenue;
no experiments in display as in El Lissitzky's Cabinet
of Abstract Art in Hanover.

Instead, we have Mondrian, the visual philosopher,
in his immaculate proto-gallery, the empirical mystic
resolutely carrying out his grand idea, the spiritualist
returning to his monklike task. "Like Brancusi," Nelly
van Doesburg wrote, "whose personality was otherwise
so different and who was much less inhibited in his
enjoyment of female company, Mondrian had adopted
a pattern of life which did not allow any realistic
prospect of ordinary domestic relationships. Each of
these artists was so devoted to his profession that there
was, in fact, little room left over in their lives for the
daily companionship of any woman. It is difficult to
imagine any ordinary woman feeling comfortably at
home either in the sparsely furnished atelier of Mondrian
or amidst the clutter of statuary with which Brancusi
surrounded himself."

The clutter of statuary with which Brancusi surrounded

himself: what Nelly van Doesburg saw as "clutter" had a powerful influence on how the gallery shows its wares. From a distance Brancusi's works seem easily identifiable. In that facile nomenclature by which we denote art by surnames, they are all "Brancusis," children of a single style. Up close, the work begins to calibrate its own standards. We are in a universe of perfect equivocation. In this, Brancusi is, as Sidney Geist points out in his splendid book on the artist, like Mondrian. Geist, with some justification, makes the claim that "Brancusi created the idea of the artist's studio in our time." He writes, "No studio has been more famous than his and, since it has been installed in a neat version at the Musée d'Art Moderne in Paris, none will be more visited. The original made an impression which, as many writers have attested, was overwhelming, with its white walls and the light falling on precious objects gleaming among rough blocks of wood and stone. It seemed at once a temple and laboratory of art..."

In 1926, when Brancusi was planning an exhibition in New York, he hoped "to build or rebuild a room in which his work may be properly seen." Geist continues with the vital matter of the pedestal, which, as handled by Brancusi, brought the sculpture directly to the floor, making the floor not a utilitarian support but an aesthetic zone, just as Mondrian's consciousness of the wall contributed to the artification of the vertical plane. These were two of the three major forces that mobilized the gallery from something with things in it to a thing in itself: the wall, outside the frame; the floor, beneath the missing pedestal. The third force, as we have already noted, was their vulgar cousin, collage.

Geist also explains how Brancusi's method — to conceal labor, to present the work full-blown, to meditate and then quickly realize — enhanced his idea of the studio

as a place for display. It was, in fact, a studio that became a gallery, Brancusi its director. He constantly rearranged his sculptures, mirroring, says Geist, "his concern for the relation between any single piece and the world." Within that studio, one of the sights of Paris in the 1920s, he could control the dialogues across space between his artworks with the skill of a great preparator, one like René d'Harnoncourt. Photographs of Brancusi's studio illustrate this. A perfect light falls in a slow deposition on the posing objects. No greater telescoping of studio and gallery can be imagined. Brancusi preserved the context of his work and thus his version of freedom from the dead spaces of the museum. He created a gallery in a studio, which then entered the museum intact, an exact reversal of the Samaras studio-bedroom in a gallery with which we began. Through a brilliant negotiation, Brancusi insisted that his studio, the uninhabited studio, would survive him. You might say he revisits it with every visitor.

This completes the trio of forces that have defined the studio and in turn have influenced the nature of gallery and museum. First, there is the mythology of the artist as a creature engaged in the mysterious business of creation, whose creative act becomes a bourgeois fetish by which the public acknowledges the power of the artwork but at the same time undercuts its subversive potentials. Second, there is the transference of this mystique from the artist to the fecund space of the studio; as representations of the studio illustrate, it is a self-reflexive process, which prompts the notion of art's autonomy, which in turn transfers to the gallery — underlining the gallery's immaculate pseudo-idealism. Third, there is the reductive *studio povera*, which, particularly with Mondrian and Brancusi, contributes to the clean, well-lighted place where art is shown.

Some time ago, when I was speaking to Hubert Damish about the often irritating durability of the white cube, he remarked how useful this white space has been, how extraordinary things have been incubated within it. I can agree that the art it showed from Cubism on effected a radical change in our modes of perception, profoundly connected to two areas: to space, the unknowable medium of all our visual discourses; and to human nature, and the explorations of its unknowable depths. But that was before public media — film, radio, television, and the computer screen — took over the task of reforming perception, producing changes far outside the gallery that have had wide social reverberation. These changes have also been seen within the gallery.

The notion of a studio clarified itself in the context of modernism and had direct and indirect relations with its sibling, the gallery. The preservation of the white gallery as a grand boutique was necessary for commerce and enabled museums to show their holdings — although in a manner which has increasingly tended toward entertainment. Entertainment is the museum's Faustian bargain, a way for the museum to survive by selling its soul in a culture that bows its knee to numbers. Given the common man's (and woman's) sneer at "elitism," it's a wonder there are serious exhibitions at all. Throughout this development, however, the white space has hovered virtually unchanged in the matrix of our culture, taking its place alongside the artist as medium, the means as medium. It too is a medium, joining these others with its mysterious alchemy. It transforms while remaining itself unchanged. Painting was the white gallery's best friend, modernism's avatar. No matter how radical its innovations, the canvas hung quietly on the wall.

But with the decline of painting as the dominant mode, the purity of the white space became compromised.

So we can now also speak of an anti–white-cube mentality, which has its own erratic history within the grand narrative of modernism, becoming aggressively manifest with postmodernism. As video, film, photography, performance, and installations became certified modes, attracting generations of the young, handmade painting became but one suburb of the artistic enterprise, to many as quaint as the art of letter-writing, devoured by e-mail and texting. Within the subcultures of contemporary art, each of these media claims precedence, an echo of the hierarchy of genres in Neoclassical art. With the intrusion of installations, video, and the rest, the white cube has become increasingly irrelevant; the gallery becomes a *site* — "the place," the dictionary says, "where something is, was, or is to be." The liaison of these art media with popular culture has brought into the gallery unruly energies which no longer have an investment in the preservation of the classical white space. Whereas the gallery once transformed whatever was in it into art (and still occasionally does), with these media the process is reversed: now such media transform the gallery, insistently, on their terms.

This paper was presented in its expanded final version in spring 2006 at the Graduate School of Architecture, Planning and Preservation of Columbia University under the auspices of the Temple Hoyne Buell Center for the Study of American Architecture. I particularly want to thank Salomon Frausto for his inventive stewardship of the production of this little book, Sharif Khalje for patient illustration research, and finally Joan Ockman, who insisted on publishing it in this beautifully designed format. — B. O'D.

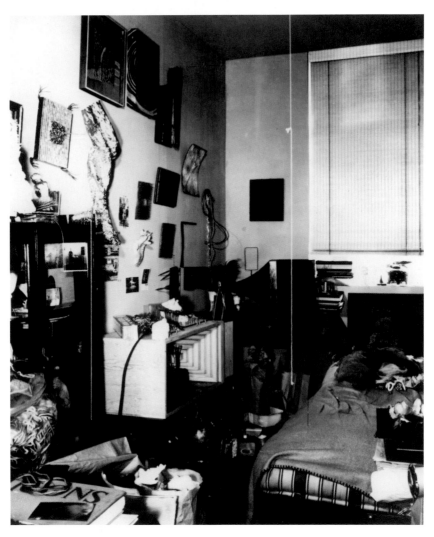

1 Lucas Samaras, <u>Room #1</u>, 1964. Installation at Green Gallery, New York

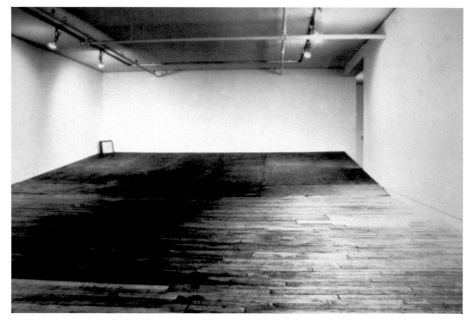

2 Vito Acconci, <u>Seedbed</u>, 1972. Installation at Sonnabend Gallery, New York

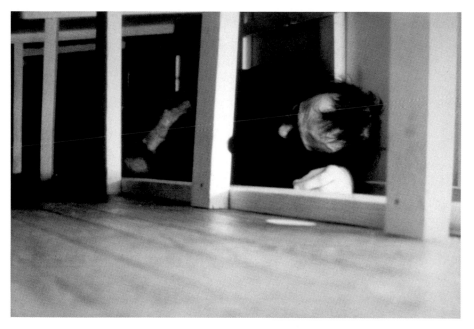

3 Vito Acconci, <u>Seedbed</u>, 1972. View with artist underneath platform

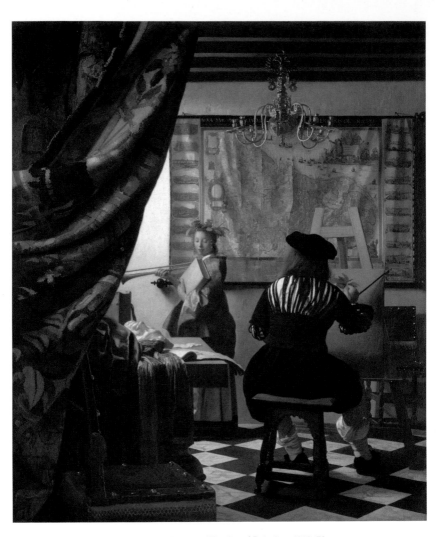

4 Johannes Vermeer, <u>The Art of Painting</u>, 1666–73

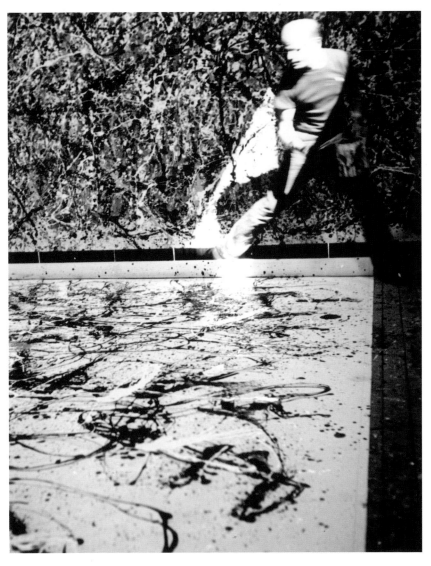

5 Jackson Pollock in his studio, East Hampton, New York, 1950, with painting-in-progress on floor, probably <u>Autumn Rhythm</u>. Photographer: Hans Namuth

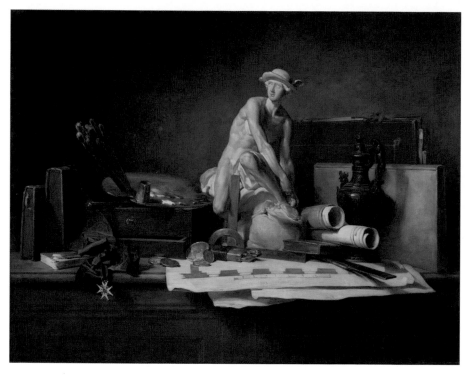

6 Jean-Baptiste-Siméon Chardin,
The Attributes of the Arts and the Rewards Which Are Accorded to Them, 1766

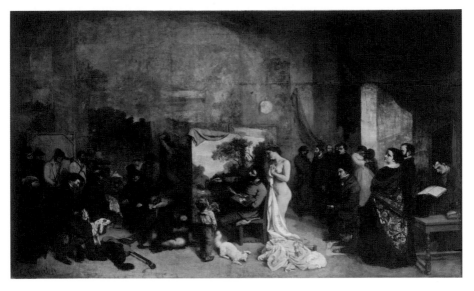

7 Gustave Courbet, The Painter's Studio, 1855

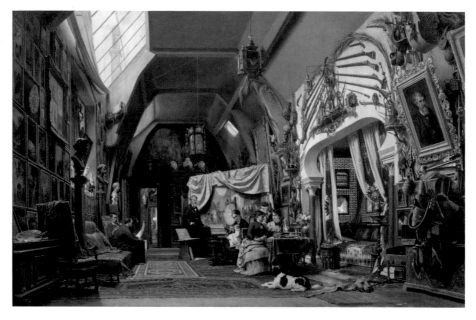

8 Charles Giraud, <u>The Atelier of Eugène Giraud</u>, circa 1860

9 Jasper Johns, Canvas, 1956

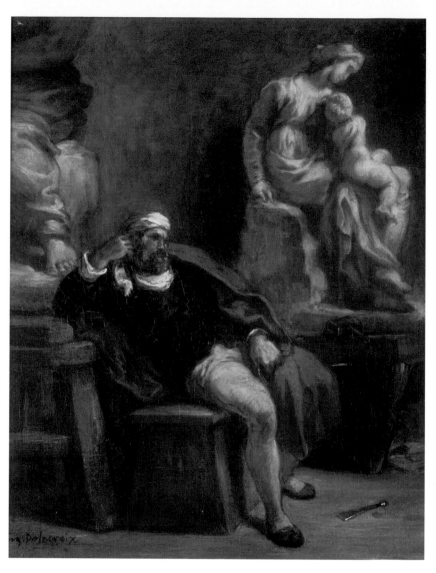

10 Eugène Delacroix, <u>Michelangelo in His Studio</u>, 1850

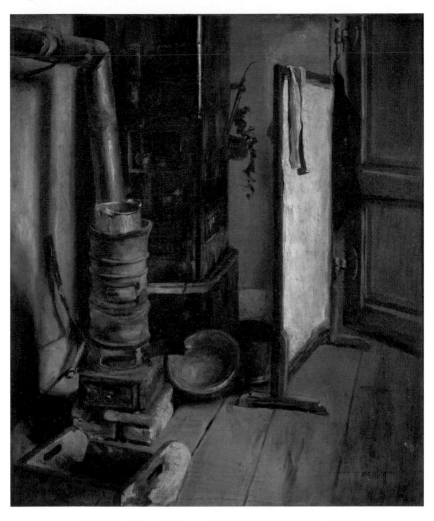

11 Eugène Delacroix, <u>Corner of a Painter's Study, the Stove</u>, 1855

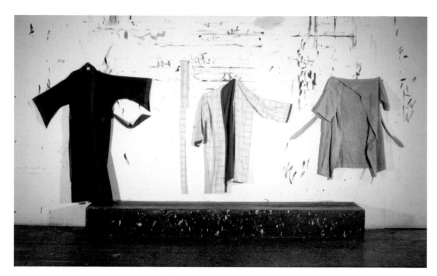

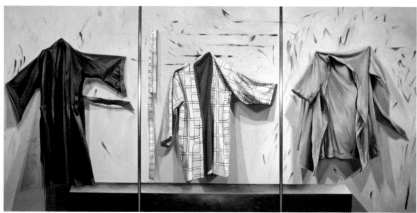

12 Interior of Lowell Nesbitt's studio, New York, circa 1967–68. Photographer unknown
13 Lowell Nesbitt, <u>Lowell Nesbitt's Studio</u>, 1967–68

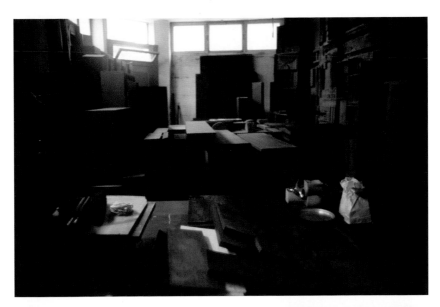

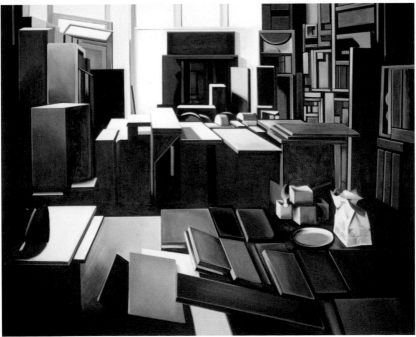

14 Interior of Louise Nevelson's studio, New York, circa 1967–68. Photographer unknown
15 Lowell Nesbitt, Louise Nevelson's Studio, 1967–68

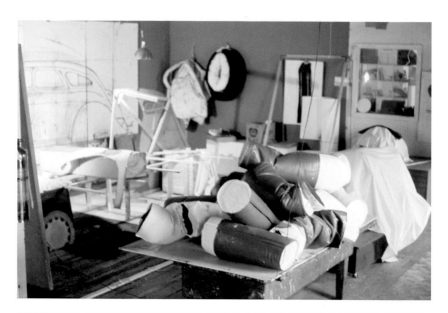

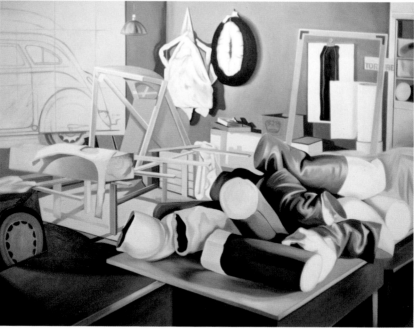

16 Interior of Claes Oldenburg's studio, New York, circa 1967–68. Photographer unknown
17 Lowell Nesbitt, Claes Oldenburg's Studio, 1967–68

18 Jasper Johns, study for <u>Skin I</u>, 1962

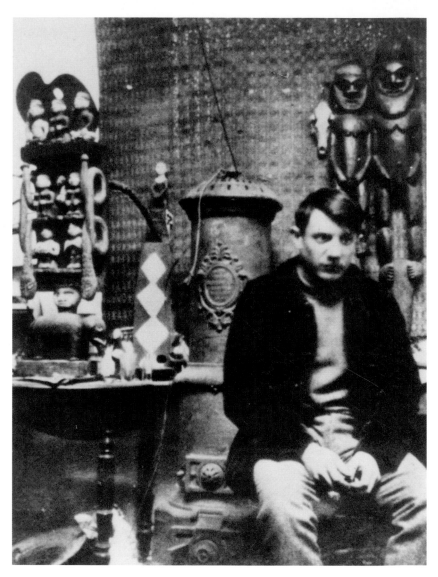

19 Pablo Picasso in his studio at the Bateau-Lavoir, Paris, 1908.
Photographer: Frank Gelett Burgess

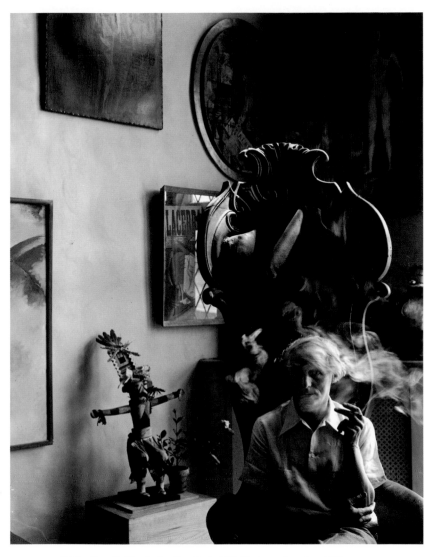

20 Max Ernst in his studio, New York, 1942. Photographer: Arnold Newman

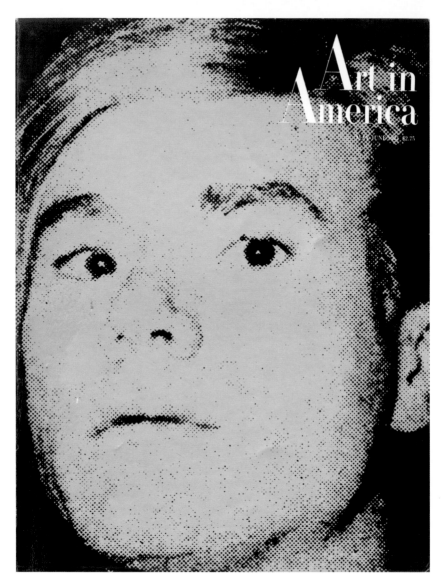

21 Andy Warhol on the cover of *Art in America*, May–June 1971

WEATHER
Mostly Sunny,
80.
Tomorrow:
Sunny, 80-85.
SUNSET: 8:22 PM
SUNRISE
TOMORROW: 5:24 AM

New York Post

© 1968 New York Post Corporation

LATE CITY

HOME EDITION

Vol. 167
No. 169

NEW YORK, TUESDAY, JUNE 4, 1968

10 Cents
15c Beyond 50-mile Zone

ANDY WARHOL FIGHTS FOR LIFE

Marcus Taking Stand

By MARVIN SMILON
and BARRY CUNNINGHAM

Ex-Water Commissioner James Marcus was expected to be the government's first witness today in the bribery conspiracy trial that has wrecked his career and saddled the Lindsay Administration with its only major scandal.

His opening testimony follows a dramatic scene in U. S. District Court yesterday when Marcus, 37, changed his plea to guilty in a surprise switch which visibly jolted four of the five other defendants in the alleged $40,000 kickback plot.

The dapper former aide and confidante of the Mayor said he was in no way coerced or promised anything to change his original plea of

Continued on Page 8

Pop artist-film maker Andy Warhol makes the scene at a recent Long Island discotheque party. Valeria Solanis, who surrendered to police after he was shot and critically wounded, is shown as she was booked last night.

Post Photos by Boxer and Engel

By JOSEPH MANCINI
With JOSEPH FEUREY and JAY LEVIN

Pop artist Andy Warhol fought for his life today, after being gunned down in his own studio by a woman who had acted in one of his underground films.

The artist - sculptor - filmmaker underwent 5½ hours of surgery performed by a four-man team of doctors at Columbus Hospital late last

Andy Warhol: Life and Times. By Jerry Tallmer. Page 3.

night and was given a "50-50 chance to live."

He remained in critical condition today and his chances for life had not improved.

At 7:30 last night, just three hours and 10 minutes after the shooting, Valeria Solanis, 28, a writer-actress, walked up to a rookie policeman directing traffic in Times Sq. and surrendered.

She reached into her trench coat and handed Patrolman William Schmalix, 22, a .32 automatic and a .22 revolver. The .32 had been fired recently, police

Continued on Page 8

22 Front page of *New York Post*, June 4, 1968

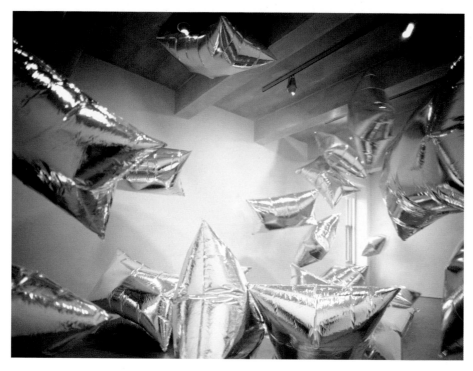

23 Andy Warhol, <u>Silver Clouds</u>, 1966. Installation at Leo Castelli Gallery, New York

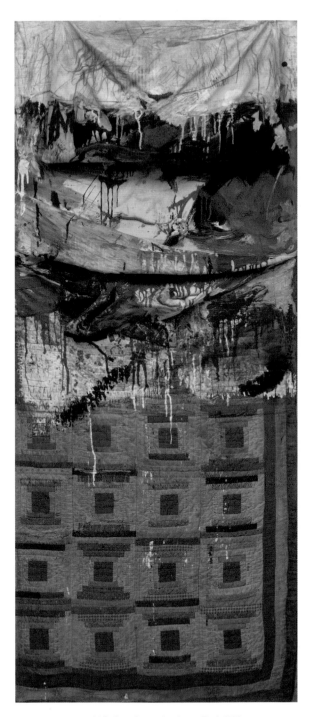

24 Robert Rauschenberg, <u>Bed</u>, 1955

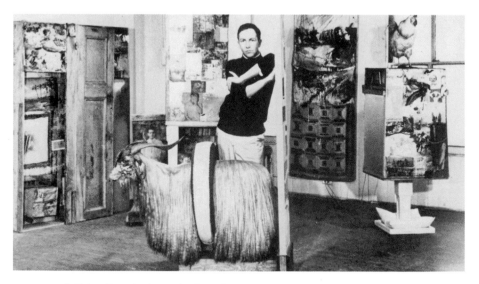

25 Robert Rauschenberg in his Front Street studio, with <u>Bed</u> on wall. New York, 1958.
Photographer: Kay Harris

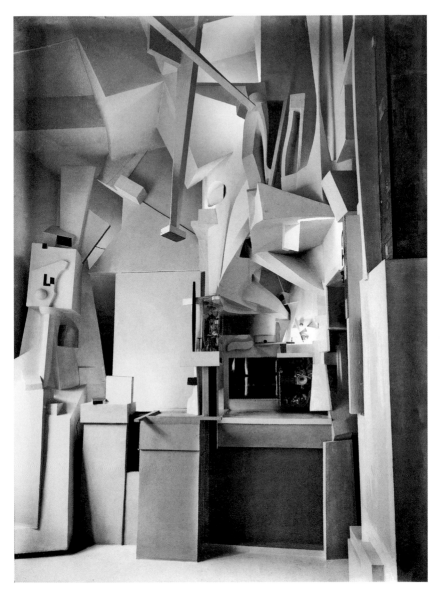

26 Kurt Schwitters, <u>Merzbau</u>, Hanover, 1923

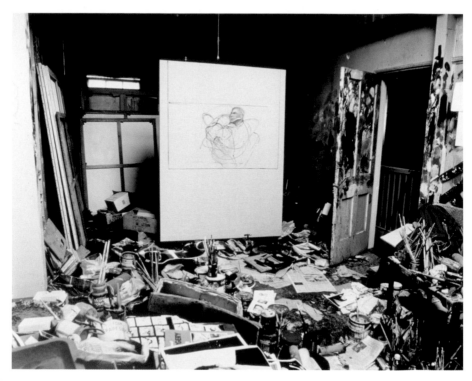

27 Reconstructed interior of Francis Bacon's studio, Hugh Lane Gallery, Dublin, 1961–92

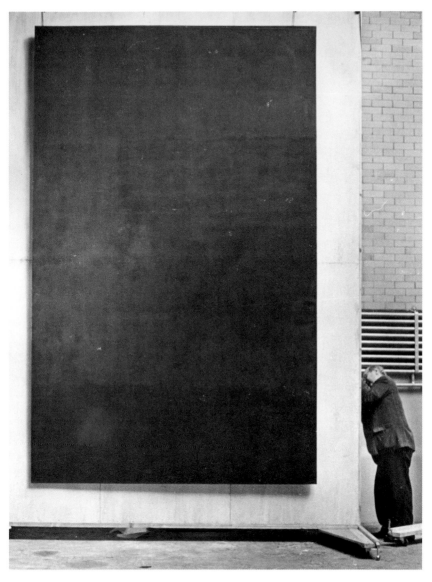

28 Mark Rothko in his studio, New York, 1964, with one of the panels for the Rothko Chapel in Houston. Photographer: Hans Namuth

29 Marcel Duchamp, Étant donnés: 1. la chute d'eau, 2. le gaz d'éclairage, 1946.
Installation at Philadelphia Museum of Art

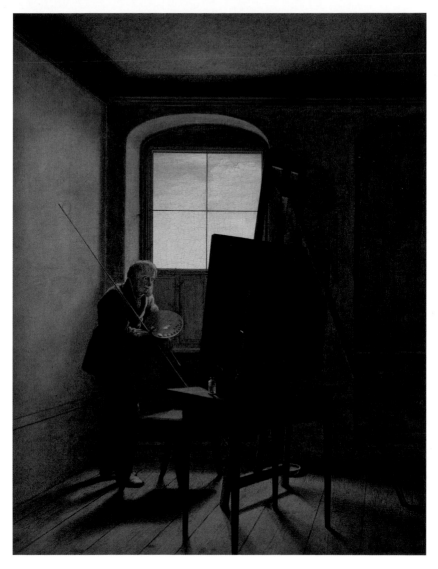

30 Georg Friedrich Kersting, The Painter Caspar David Friedrich in His Studio, 1812

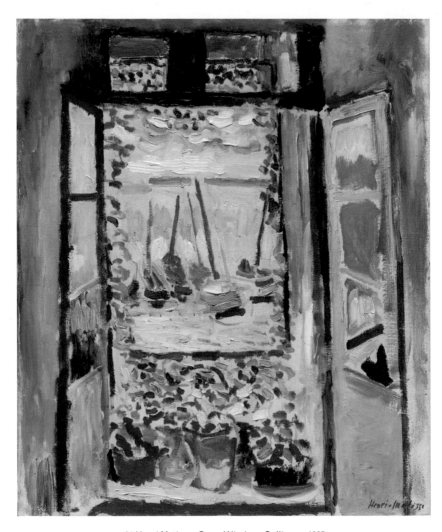

31 Henri Matisse, <u>Open Window</u>, Collioure, 1905

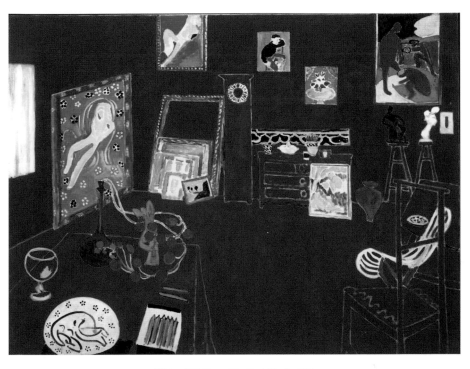

32 Henri Matisse, The Red Studio, 1911

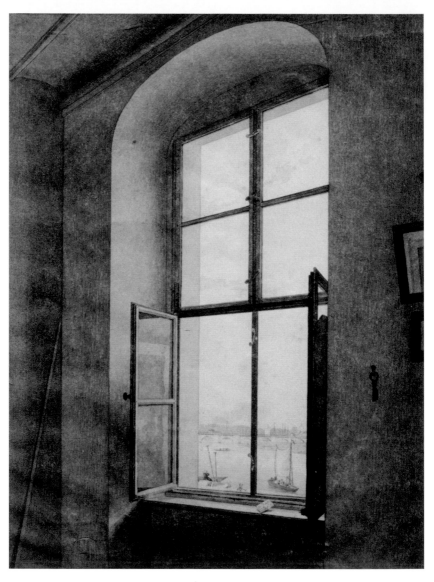

33 Caspar David Friedrich, <u>Right Window of the Artist's Studio</u>, 1806

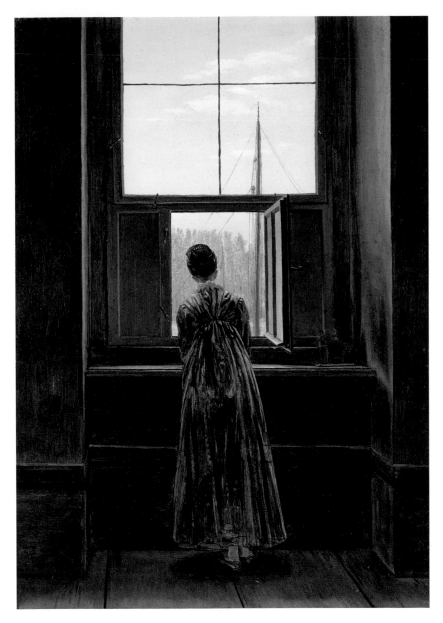

34 Caspar David Friedrich, <u>Woman at the Window</u>, 1822

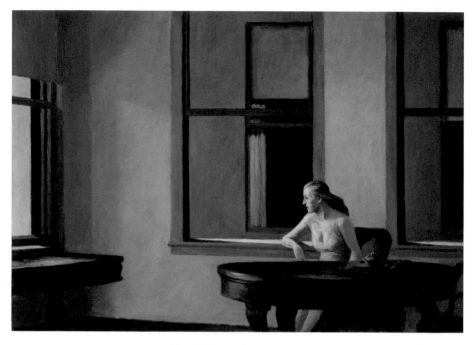

35 Edward Hopper, <u>City Sunlight</u>, 1954

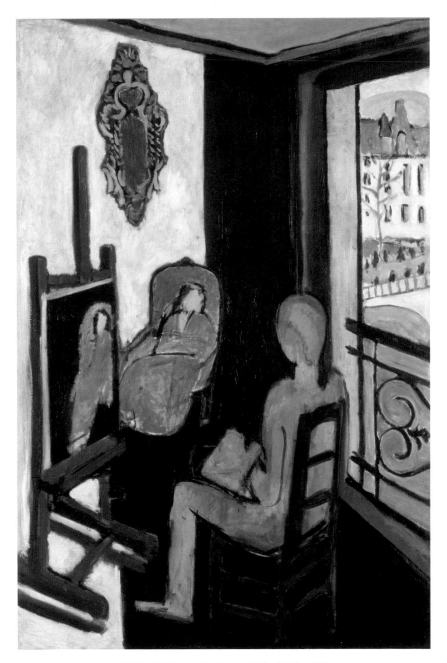

36 Henri Matisse, <u>The Painter in His Studio</u>, 1916

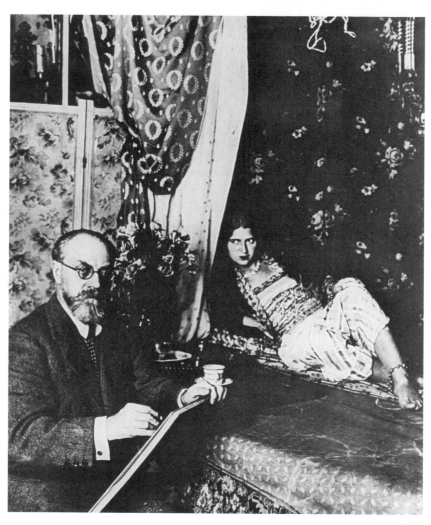

37 Matisse in his studio, Nice, 1928, with his model Henriette Darricarrère. Photographer unknown

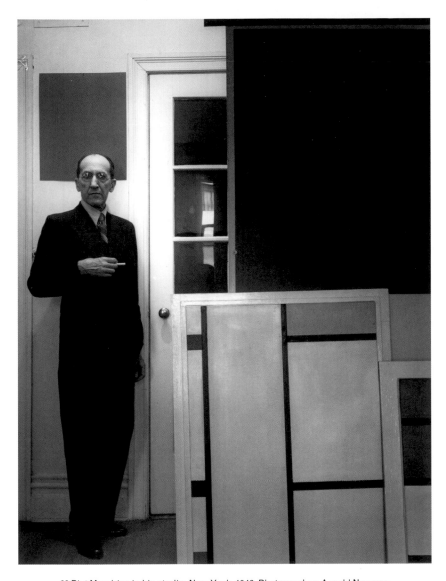

38 Piet Mondrian in his studio, New York, 1942. Photographer: Arnold Newman

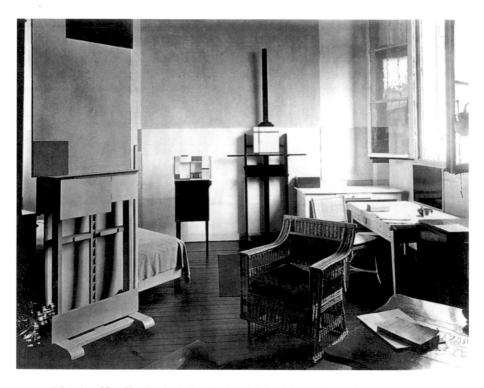

39 Interior of Piet Mondrian's studio at 26, Rue du Départ, Paris, 1926. Photographer unknown

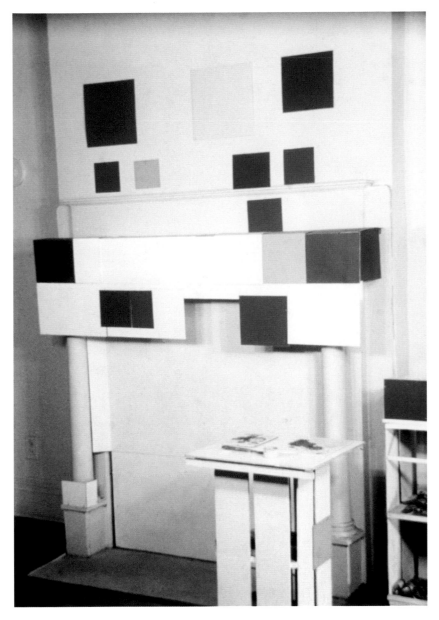

40 Fireplace with stool in Mondrian's studio, New York, 1944. Photographer: Harry Holtzman

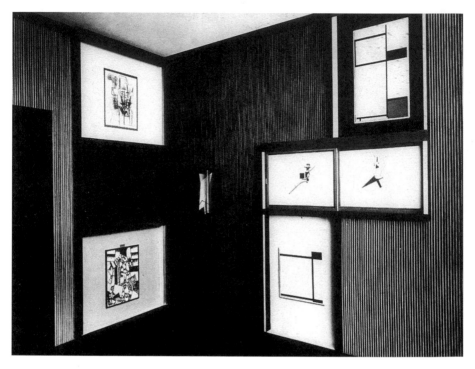

41 El Lissitzky, Cabinet of Abstract Art, Landes Museum, Hanover, 1928